My Taoist Vision of Art

Sal Kapunan

Sal Kapunan

Photographs by

William A. Bake
David S. Hamilton
and Sal Kapunan

1999

Parkway Publishers, Inc.
Boone, North Carolina

Library of Congress Cataloging-in-Publication Data

Kapunan, Sal, 1932-
 My Taoist Vision of Art / Sal Kapunan ; photographs by William A. Bake and David S. Hamilton .
 p. cm.
 Includes bibliographical references and index.
 ISBN 1-887905-12-X
 1. Kapunan, Sal, 1932- 2. Outsider art--Florida. 3. Taoism. I. Bake, William A., 1938- II. Hamilton, David S. III. Title.
 N6537 .K28 K37 1999
 709' .2--ddc21 98-37584

 CIP

Layout and Design by Robin Ann Aylor

Dedication

I lovingly dedicate this work to my wife, Ruthe, who has constantly encouraged me to pursue art and to write. I also dedicate it to my deceased parents: Salvador and Catalina. When I wrote to my mother about my art in 1991, she wrote back saying, "I admire you for doing what you cannot do." I knew exactly what she meant.

Foreword

Folk art in America was "discovered" in the 1930s by collectors and *avant-garde* artists who recognized the visionary qualities in seemingly mundane materials such as quilts, weathervanes, and cigar store Indians, and celebrated them for the creative genius they represented. The makers of such art were often anonymous, but collectors quickly discovered that quaint living artists, such as Grandma Moses, could still be found at work. More recently, the term "folk artist" has taken on a far more eccentric definition, and, when used by collectors, it usually refers to someone so unusual in his or her own community as to be termed an "outsider." In this book, Sal Kapunan, as both a practitioner and a student of outsider art, makes his own contribution to the literature of the field.

At first glance, Kapunan would hardly be an outsider. He is well-educated holding a doctoral degree each in philosophy and education. He has achieved considerable success, largely as a result of mastering Western ideas of real estate speculation. Art historians typically view outsider artists as working through their worldly and personal failures. Sal Kapunan is a different kind of outsider. His work represents a visual processing of his personal achievements, not simply educational and financial achievements, but those as a human being in balance with the world. In other words, as a Taoist.

He is, himself, somewhere on a cultural continuum, no longer of the Philippines where he was born and raised, but not so completely American that his vision is colored by overfamiliarity with the razzamatazz and hurly burly of post-industrial life at the dawn of a new millennium. He is a natural questioner, perhaps the best kind of outsider. And, as an outsider, he sees things that we, on the inside, miss and he calls attention to them, stripping us of our own contentment and making us aware of what we take for granted.

It is particularly important to understand that most of Kapunan's artwork has been created within the context of garden building, both in Florida and in North Carolina. The uniting of art with ornamental horticulture precedes recorded time, but certainly we know that the ancient Greeks and Romans placed sculpture in garden settings as a means of enhancing both the man-made and natural elements, creating something greater than the sum of the two parts. This urge remains ubiquitously with us today, as any roadside shop selling concrete St. Francis of Assissi statutes and plywood pictures of women bending over will testify. This is, of course, the lowbrow end of the concept's spectrum.

At the other end are the elaborate efforts such as the "garden of cosmic speculation" begun in the Scottish Borders by physicist Charles Jencks and his wife Maggie Keswick in 1990. This garden, which grew out of Keswick's interest in Taoism and Chinese gardens, is "based on specific ideas rather than abstract moods," according to the British magazine *Country Life*. These ideas are represented in the garden by such things as a large sculpture in the form of a double helix and a frieze atop the greenhouse that reproduces Lagrange's equations of classical mechanics.

So, too, are Kapunan's gardens about ideas rather than moods. One suspects that if Kapunan had never started to make art, his gardens would have been based on Eastern principles of simplicity and repose. But he did, in fact, begin to make art and now, rather than simplicity and repose, his gardens have become wonderlands of fantasy and creativity, yet one can still see the Taoist basis that underlies his work. But this is a Taoism that has had a head-on collision with Postmodernism.

When one looks at the garden and the components out of which Kapunan's art is made—vacuum cleaners, auto gas tanks, tennis racquets, bicycle parts, telephone sets and so forth—the results should be mayhem. But, instead, there is order. In fact, there is more than order. There is a serenity that feels very Eastern, even in the non-orientalness of the setting. The art is not junk sculpture—it is a conscious reordering of the meaning of things, a reforming of artifacts that are moving out of their previous form, much like the journey of Sal Kapunan from the Philippines to the United States, and into something else. These things—gas tanks and Kapunan alike—are what they were and what they have become, all at the same time, as if past and present were both visible at once, like an infinity mirror. In the case of the Boone garden, it is a garden of pathways, of wood and branches, ivy, pine needles and pebbles. It is the Orient, and Appalachia, and modern industrialism and the world of handicraft, all merging under some locust and pine trees in the backyard of a most remarkable man.

In terms of Appalachian history, this is a good thing. For too long, the general public and many scholars have viewed traditional mountain culture as something eternal, a perpetual Scottish-Irish Nirvana of storytellers and dulcimer players. Kapunan—the philosopher, artist, and gardener—reminds us that no mountain is an island, that change is not only inevitable but healthy and that the view from outside can be quite remarkable.

Charles Alan Watkins
Appalachian Cultural Museum
Boone, North Carolina

Preface

During the summer of 1997, I wrote a manuscript about visionary artists and visionary art. My purpose was to shed some understanding on this interesting genre of art. It is often assumed that visionary art lies outside the pale of mainstream art.

Since my work belongs to this type of art, I wanted to verify that no one else has done what I have been doing. I also wanted to test my assumption that each visionary artist is unique because he or she derives his or her creations from the inner self; and that such artists do not copy or mimic existing artistic traditions. For this reason, their art has no history and is not part of art history. If so, visionary art is distinct, unique, and truly original.

I studied various collections of visionary art including the oldest known collection, which dates back to 1918. My survey and analysis covered contemporary visionary artists, including myself. I included myself only to establish my credentials in order to write about the subject.

I submitted the manuscript to Parkway Publishers. After about a week, Dr. Rao Aluri, publisher and editor, had proposed a different idea. He wanted me to shorten the manuscript and reduce it to the status of an introduction. He wanted the bulk of my manuscript to be about my artwork. In his letter, he wrote, "I would like to see more information and photographs/illustrations of Kapunan's work, his materials, techniques, and examples of completed artwork. This section may include information on Kapunan's landscape design work as well."

This work is my attempt to comply with Dr. Aluri's proposal. In fact, Dr. Charles Watkins, the director of the Appalachian State University Cultural Museum, completely concurred with Dr. Aluri's opinion. The Cultural Museum will become the co-publisher of this work.

After I finished writing this work, I became convinced that Aluri and Watkins were right and wise in encouraging me to write about my work. As far as I know, no visionary artist has written about his or her work.

What we know about them has been written by journalists who interviewed them or by art historians and critics who superimposed their own interpretations of the artwork. This may be the first time that a visionary artist has written about his creations.

As a philosopher, I have often asked myself whether a work of art has a life or an essence. My response is that the life of a work of art is the idea that the artist has imbued upon the work. It is the artist's idea that the viewer understands as she or he views the work. For this reason, I owe it to my art admirers to explain the ideas behind my creations.

At this point, I want to thank both Dr. Aluri and Dr. Watkins for encouraging me to write this work and for their courage to take the risk of publishing it. Michelle Lakey and Julie Shissler edited the manuscript, Robin Ann Aylor typeset the book, and Bill May, Jr. designed the cover and scanned the photographs.

Sal Kapunan
Cape Coral, Florida

Table Of Contents

Dedication
Foreword
Preface

Part One: Visionary Art and Its Meaning

1. The Beginnings of Visionary Art
2. The Prinzhorn Collection of the Art of the Mentally Ill
3. The Dubuffet Collection of Brut Art
4. The Janis Collection of Self-Taught Artists
5. The Rockefeller Collection of Folk Art
6. The Hemphill Collection of Folk Art
7. Some Examples of Visionary Art
 James Hampton
 Eddie Owens Martin
8. The Influence of Visionary Art

Part Two: Kapunan's Visionary Art

9. Brief Autobiography
10. The Brasstown Experience
11. Some Principles of Creativity
 The Taoist Point of View
 The Taoist Artist
 The Western Point of View
 The Artistic Idea
 Visualization and the Imagination
 Using Symbols for Visualization
 My Personal Symbols
12. Some of My Artwork
 Decorative Pieces
 Whimsical Pieces
 Landscaping and Gardening
 Boone Landscaping and Gardens
 Architectural Design
 Symbolic Artworks
 Monumental Sculptures
 Chief Caloosa
 The Four Races

Medusa
Uphill Mountain Biker
The Fire Goddess
The Plowman of Appalachia
Sunburst
Hands
Hurricane Hugo
Chairman of the Board
Emerging Buddha
Self-Portrait
13. Gertie, the Greeter
The Artistic Idea
Visualization of the Artwork
The Making of Gertie
Installation and Celebration
14. How My Artwork Has Affected My Life

Selected Bibliography
Index

List of Photographs
A. Cape Coral Landscaping and Gardens
B. Boone Landscaping and Gardens
C. Cape Coral and Boone Whimsical Sculptures
D. House Birds in Boone and Cape Coral
E. People-like Sculptures in Cape Coral and Boone
F. Totem Poles in Cape Coral
G. Brasstown Carvings

PART ONE

Visionary Art and Its Meaning

Visionary Art and its Meaning

The Beginnings of Visionary Art

In a sense, every artist is visionary because what an artist does is visualize artwork before it is actually made. Nevertheless, during the past 25 years, a specific body of artwork has been designated as visionary. These are the works of self-taught and untaught artists, and therefore without formal training, whose creativity arises from their innate personal visions. They were not aware, at least in the beginning, that what they created was artistic.

Visionary art has also been called vernacular, folk, primitive, naive, self-taught, brut, outsider, and other less flattering terms. Since 1972, the term "outsider art" has gained currency, especially in Great Britain. Roger Cardinal, a British author, wrote a book entitled *Outsider Art* in 1972. As Cardinal used the term, it referred to the work of artists who lived outside the mainstream culture because they were frequently isolated in mental institutions or in prisons.

Some American authors who have written about outsider artists and also used the term "outsider" do not limit their inclusions to artists outside the mainstream culture. To those authors, every self-taught artist is an

outsider, which blurs the meaning of the term. For this reason, I prefer the term visionary because it denotes something more positive and laudatory. Without a doubt, every self-taught artist has visions.

But my main reason for choosing the term visionary is patriotic. In 1992, the US government formally endorsed it. In November 1991, Senator Barbara Mikulski of Baltimore submitted a resolution to the 102nd Congress, which, in part, read:

> *Whereas visionary art is the art produced by self-taught individuals who are driven by their own internal impulses to create;*
>
> *Whereas the visionary artist's product is a striking personal statement possessing a powerful and often spiritual quality;*
>
> *Whereas prominent among the creators of visionary art are the mentally ill, the disabled, and the elderly; ... Now, therefore, be it resolved*
>
> *by the Senate (the House of Representative concurring), that it is the sense of the Congress that (1) visionary art should be designated as a rare and valuable national treasure to which we devote our attention, support and resources to make certain that it is collected, preserved, and understood; and (2) the American Visionary Art Museum is the proper national repository and educational center for visionary art.*

This resolution passed unanimously in both the Congress and the Senate on August 12, 1992. The resolution authorized the design and construction of the Museum in the Inner Harbour of Baltimore, Maryland.

The American Visionary Art Museum is a beautiful, state-of-the-art cultural institution. As an official policy, it has a limited permanent collection. By changing the exhibits several times a year, public interest is maintained. Each exhibit has a specific theme determined primarily by a guest curator who knows, loves, respects, and values visionary art.

As the following collections will show, there are various categories of

visionary art which warrant the use of different terminology. The Prinzhorn collection deals only with the works of mentally insane who were confined in mental institutions. This collection justified the use of the term "outsider art," which meant outside the mainstream culture. The Dubuffet collection consists of works by "non-artists" thus justifying the term, "art brut." The Janis collection consists of works by untrained, "self-taught" artists. The Rockefeller collection specialized in certain types of folk arts. It justifies the use of "folk art" to refer to certain types of visionary art. The Hemphill collection specialized in the art of living folk artists.

The Prinzhorn Collection of the Art of the Mentally Ill

Dr. Hans Prinzhorn (1886-1933) undertook the first collection of visionary art in 1918. He was a psychiatrist who had studied art history in college.

While studying the drawings of his patients for diagnostic purposes, he marveled at the intricacies of some of the drawings. He later wrote, "Untrained mentally ill persons, especially schizophrenics, frequently compose pictures which have many of the qualities of serious artists." [Prinzhorn, 1972, p.5] Normally, such drawings were destroyed after they had been clinically studied or became part of a patient's confidential file. Prinzhorn wrote to former classmates who were practicing psychiatry in other countries. In less than two years, he had collected over 5000 works of over 450 patients from Germany, Austria, Switzerland, Italy and Holland. In 1922, he published the entire collection with his commentaries about each drawing.

The Dubuffet Collection of Brut Art

Jean Dubuffet was a successful wine merchant when the Second World War broke out. During the war, he spent his time experimenting on his unique style of painting. Right after the war, he was surprised how the art world of Paris bought all of his paintings.

After he became acquainted with the Prinzhorn collection, he decided to devote time collecting works of non-artists such as children, street people, hermits, factory workers, housewives, psychic mediums, and mentally ill

people. He called his collection "Art Brut." The French term *brut* normally means crude or gross. To him, however, it meant original, unique, pure. He regarded his own work as brut. In 1949, he wrote in part about his collection:

> What we mean by this term [Art Brut] is work produced by people immune to artistic culture in which there is little or no trace of mimicry; so that such creators owe everything—their subject-matter, their choice of materials, their modes of transcription, their rhythms and styles of drawing, and so on—to their own resources rather than to the stereotypes of artistic traditions or fashion. Here we are witness to the artistic operation in its pristine form, something unadulterated, something reinvented from scratch at all stages by its maker, who draws solely upon his private impulses. [Dubuffet, p.41]

He proudly exhibited his collection in various places in Europe and once in Long Island, New York.

The Janis Collection of Self-Taught Artists

In 1939, Sidney Janis, an American, began collecting the works of self-taught artists. That same year, he wrote a book entitled *They Taught Themselves*. He also exhibited their work at the Museum of Modern Art in New York City with the title "Masters of Popular Painting." The collection was the work of sane, normal people who taught themselves how to paint. He referred to their works as "raw visions." From his point of view, they were crude versions of academic art. Those "weekend" artists were familiar with the European artistic tradition, and virtually all of them were white and of European ancestry.

The Rockefeller Collection of Folk Art

The Abby Aldrich Rockefeller Folk Art Center in Williamsburg, Virginia, is probably the biggest museum for folk art. It was opened in 1957 and contains folk art made before 1850. The museum idealizes frontier life and domesticity prior to the Industrial Revolution. It contains Mrs.

Rockefeller's personal collection, which she donated to Colonial Williamsburg in 1939.

The Rockefeller Museum dealt only with the artwork, not with the artists who were deceased or unknown. The museum's primary criteria for inclusion were colonial or pre-industrial themes and the quality of the work.

The Hemphill Collection of Folk Art

The Herbert Hemphill Collection is among the largest private collections of folk art in the country. Son of a wealthy industrialist, Hemphill dropped out of college to make art collecting a career. He focused on art made by common people. For this reason, he preferred the term *folk art*.

In the late 1960s, he was introduced to Edgar Tolson, a folk artist from the Appalachian Mountains of Kentucky. He was so impressed by Tolson that he decided to focus his collection on living folk artists.

In 1974, he coauthored, with Julia Weissman, a book entitled, *Twentieth Century Folk Art and Artists*. This endeavor gave him the motivation to search the country for living folk artists.

In 1986, the National Museum of American Art in Washington, D.C. acquired 427 works from his collection. Elizabeth Broun, the Museum director remarked, "Instead of appearing marginal, folk art began to seem an essential part of our visual arts. . ." [Hartigan, p.ix]

Some Examples of Visionary Art

JAMES HAMPTON

James Hampton was a religious visionary. When he died in 1964, his landlord found a magnificent sculpture that filled the whole garage. Nobody had any inkling that he was working on an art project. The oversize sculpture was called "The Throne of the Third Heaven of the Nation's Millennium General Assembly." The work was made of several assemblages of old furniture, light bulbs, glass jars, and cardboards. Every surface was completely covered with silver and gold foils.

He created 50 thrones, altars, pulpits, crowns, and wall plaques. He

made geometric patterns in pen and ink; he also made various symbols and inscriptions. One of the inscriptions tells us his visionary inspiration. In a typewritten statement, he wrote, "This is true that on October 2, 1946, the Great Virgin Mary and the Star of Bethlehem appeared over the Nation's capital."

Hampton was employed by the General Services Administration in Washington, D.C. It appears that he started working on this project after his vision in 1946 until his death. Part of this sculpture is permanently displayed at the National Museum of American Art in Washington, D.C. I marveled at the intricacy and beauty of this work. A larger portion of the artwork is exhibited in the Walker Art Center in Minneapolis, Minnesota, in the section called "Naives and Visionaries."

EDDIE OWENS MARTIN

Eddie Owens Martin was what I would call an unconventional quasi-religious visionary. It is not clear whether he had an actual vision of the imaginary tribe he was head of; or whether the imaginary people he called Pasaquanites were pure figments of his imagination.

He was born in poverty on a small farm near the town of Buena Vista, Georgia. He worked as a sharecropper until his late teens. Then, he decided to leave for New York City as a starting point for his world exploration.

His exploratory venture died quickly in the Big Apple. Instead of traveling, he found himself in the company of the lost, alienated, and rejected of society. In order to survive, he committed small crimes, including prostitution.

When he was 40 years old, his mother died, and he learned that he had inherited her small farm. When he arrived at the farm, he had a vision of being the founder and leader of extraordinary group of people. They looked human but they were all good looking and had hair that naturally stood towards the heavens because they served as radio receptors for extraterrestrial messages. They were citizens of the universe but were temporarily residing in Pasaquan.

Completely untaught, Martin proceeded to paint the walls of his house, both inside and outside. He chronicled the daily, imaginary activities of its

dwellers. Life seemed like an everlasting party where people sang, danced and played. Misery seemed to have vanished and nobody worked.

When he ran out of walls to paint, he built concrete walls around his property. Compulsively, he transformed his property into an art gallery or museum. As head of his community, he anointed himself as ST. EOM, an acronym for Eddie Owens Martin. As befitted his lofty position, he created ornate, colorful, artistic coats and capes. He surprised his many visitors by appearing in his regal and elegant costumes. At times, he also surprised them by wearing nothing at all.

Martin was barely literate, yet he left volumes of notebooks filled with thousands of drawings, showing the activities of his imaginary subjects. His vision not only provided him a source of income from tourists but also enabled him to have a productive and very interesting life. In fact, it was a fairy-tale life that could have gone on forever.

Unfortunately, cancer put a damper on his charmed life. As the disease progressed, he ended his life with a bullet in 1985.

From 1950 to his death, he created a tremendous body of work that is truly admirable and beautiful. By creating a visionary reality, he entertained others. By sharing his world with others, he enriched their lives. His home has been turned into a museum by the state of Georgia and is a major tourist attraction.

The Influence of Visionary Art

In 1993, Maurice Tuchman and Carol Eliel curated an art exhibition comparing the work of academic artists with visionary artists. They also edited a companion book entitled *Parallel Visions*. The title was very apt, as the viewers saw similar compositions. That impression, however, is far from the truth.

What actually happened was that the academically trained artists simply copied some of the works of visionary artists. As Eliel pointed out:

In *Parallel Visions* we attempt to explicate what the artist Gregory Amenoff has called the "moral influence" of outsider artists on the 20th century art. The outsiders' "sense of focus," their "intensity,"

and their "lack of guile" are what appeal to the mainstream artists, rather than "any given style or subject." [Tuchman and Eliel, p.17]

This was the first time such an exhibition was ever done in the USA. It systematically showed the linkage between the two art worlds. The linkage, however, is one way--from visionary to mainstream.

Tuchman also pointed out that this artistic borrowing has been going on since 1912.

The eighty-year tradition of modern artists, finding revelation in the unadulterated, unmediated expressions of untaught visionaries continue with the young professional painters and sculptors emerging today. This tradition, commencing around 1912, may be seen to be the precise counterpoint to the ratiocinative, philosophical tradition in the 20th century art. [Tuchman and Eliel, p.12]

Frank Maresca calls attention to the discontent felt by some artists who are creating work with mainstream tradition. According to him,

The history of modern art is bound up by implication with self-taught or so-called naive approaches because that history contains so many examples of artists attempting to unlearn their training and reauthenticate their means of expression. [Maresca and Ricco, p.3]

It is clear, therefore, that Visionary Artists have enriched and rejuvenated mainstream art. Visionary Artists had the courage to make creations of original, unique artworks. By doing so, they have enlightened and inspired many people who have known their work.

PART TWO

Kapunan's Visionary Art

Kapunan's Visionary Art

Since every visionary artwork is unique and often idiosyncratic, I cannot say that my work is typical of visionary art. In fact, there is no "typical" visionary art. This is because the term *visionary art* does not refer to an art movement or art school. It is not an "ism" like Impressionism, Expressionism, Realism or Surrealism.

Visionary art is better understood for what it is not than for what it is. This is because the term is a loose classification of a body of artwork that has no history. It has no history because it is not derived from mainstream art. For this reason, many writers have preferred the term *outsider art* which means outside the mainstream of art.

My artwork is more than an example of visionary art. The discussion of my principles of creativity, my creative process, and specific art pieces will give the reader an understanding and empathy with art in general. Whether the art is a part of mainstream tradition or outside, it starts in the mind, in the brain of an artist. Art starts with a vision from within. When the artist acts on his or her vision and brings it out into reality, there is a "visual art."

Modesty aside, the special value of my writing about my art lies in the

fact that I may be the first visionary artist who writes about his own work. Very often, we learn about visionary art through secondary sources: art historians, journalists, museum curators, and art teachers. When I hear museum docents make comments about art pieces, I often wonder whether what is said is a speculation or something superimposed on the work. Unfortunately, few artists have written about their work. I will discuss my work as simply and as honestly as I can.

Brief Autobiography

Some people have asked me, "How did you go from teaching philosophy to doing art?" The answer is quite simple.

In 1962, I obtained a Ph.D. in philosophy from Santo Tomas University in Manila, Philippines. I taught for four years in the Philippines before I immigrated to the USA. I taught philosophy in West Chester State College (now a university) in Pennsylvania. When I did not get tenure, I realized that finding a teaching position in philosophy would be difficult.

I decided to matriculate in a doctoral program in education in the hope of finding a job in that field. I enrolled at University of Pennsylvania but the university could not grant me a scholarship. Temple University granted me a two-year graduate fellowship. I was able to obtain my Ed. D. in 1973 and found employment at La Salle College in Philadelphia.

In 1977, I accepted a teaching position at Temple University in the Department of Foundations of Education. Little did I know then that this department was going through hard times. Enrollment in the college of education was going down because public schools were not hiring new teachers. They were not hiring new teachers because enrollment in the elementary and secondary schools was declining.

By 1979, there were serious rumors about some departments being in danger of being phased out, including my department. The following year, what I dreaded actually occurred. One professor became part of the Elementary Education Department. Another one joined the Secondary Education Department. The rest of us were terminated and the department ceased to exist.

The most shocking part of this chain of events was the realization that no jobs existed anywhere in the country. Dwindling enrollment was a national phenomenon. I realized I had to get out of teaching and find a new line of work. This would entail new training and job hunting. Twenty-five years of my professional life suddenly came to naught.

After days of indecision, I hesitantly chose real estate sales. I obtained a sales license for the State of Pennsylvania. Within a two-week period, I knew that selling was not my strong suit. In the business lingo, I was a "poor closer". While studying a book on selling, I came across an anecdote of a real estate salesman who had majored in philosophy. One day, he went to his manager and announced that he was quitting.

"Why would you do that? You are our best salesman in this office!" the manager exclaimed. "I have just found out," the salesman explained, "that money in this business is not in sales but in investments."

That same day, I decided to quit being a salesman. However, I would not formally quit until after I had used the multiple listing books to identify and acquire rental properties. My wife and I bought three apartment buildings, with a total of 21 units. Both of us worked full time in the cosmetic rehabilitation of Victorian buildings near the University of Pennsylvania.

We hired a crew of different craftsmen to do whatever was needed to make the units rentable. Within two to three months, we quadrupled our rental income by renting to young professionals and graduate students. By January 1985, we had accumulated over 50 units and could afford to retire. By July 1985, we moved to Cape Coral, Florida. A real estate management company managed our rental properties while we enjoyed the Florida amenities.

This real estate experience was a necessary and valuable transition from academia to visual arts. In managing rental properties, I learned various skills necessary for the repair and maintenance of each unit. These manual skills would become useful in my artwork later on.

The skills necessary to do the kind of artwork I do are basically construction and assemblage. There are many people who know how to construct and assemble but they do not do artwork. As we would say in

philosophy, these skills are necessary but not sufficient. As I will explain later on, the essence of making art is in the artistic idea formulated by our minds.

The Brasstown Experience

In order to escape the summer heat of Florida, we bought a condominium in Boone, North Carolina in 1986. In the summer of 1988, my wife, Ruthe, wanted to attend a one-week, intensive course in Raku at John C. Campbell School of Folk Arts in Brasstown, North Carolina. My wife insisted that I go with her and suggested that I take one of their courses. I registered in wood carving because I wanted to carve faces on my walking sticks.

I underestimated the distance between Boone and Brasstown. As a result, we arrived there about an hour late. We missed the class orientation that evening.

The next day, I showed up in class with my walking sticks. I expected to hear a lecture about carving techniques, tools, safety measures, and so on but no such thing transpired. I looked around and saw everyone carving on white blocks of wood. The teacher asked me if I had a project. I told him that I did and showed him my walking sticks.

I proceeded to carve on my walking sticks as best I could. To my surprise and gratification, the faces of "wood spirits" were coming out magically. Each face took me about 20 minutes.

I realized I had a problem. How was I going to spend the rest of the day? What would I do for the rest of the week? Just to kill time, I picked up some scraps thrown away by the other carvers and carved faces on them. By lunchtime, I had carved eight faces on various surfaces.

I finally figured out what "instruction" meant in my class. The teacher would answer any questions asked and would offer help if requested or when he saw the need for his assistance. Otherwise, he left you to yourself. Periodically, he came around my work area to check what I was doing, but said nothing.

In the afternoon, I walked around the campus looking for materials to work on. I found a stack of firewood and picked up pieces that talked to

me. I carved what I saw in them.

After our evening meal, we drove around to check out this small community. My wife spotted a tree stump partly buried in mud. She offered to clean it up in the bathtub. For two days, I carved a self-portrait on the stump. The natural grains of the pinewood suggested and defined the facial features. Even though I do not wear a beard and mustache, the natural grains seemed to suggest these features. I later realized that I was doing art in a distinctly oriental way called Taoist.

My new project, the self-portrait, called the attention of some of my classmates. Before long, the word spread and students from other classes were coming into our classroom to see what I was doing. I was slightly baffled by this attention.

On the last day of classes, late in the afternoon, we were asked to bring our creations for the week to the auditorium for the whole school to view. Most of my classmates displayed 2 to 5 pieces. I had 26. I felt like a monster because people were staring at what I made.

Each teacher said a few parting words especially to their students and mentioned some highlights of the week. My carving teacher too stood up to say a few words. Pointing to my 26 pieces, he said, "I take no responsibility for these things; and I do not take credit either."

My teacher's remarks seemed to imply that I might have been out of order. So, I asked one of my classmates to tell me what instructions were given during the orientation. He told me that students were supposed to buy blank pieces of balsa wood from the school store. We were expected to check out a carved figure from the store and use it as a model. I realized then that for the whole week, I was nonconforming to procedures and school expectations.

At first, I felt shocked and embarrassed. After I recovered, I actually felt pleased for the error. I would not have been happy copying some model. I still do not know what I would have done, had I known what was expected of me.

That "mistake" in Brasstown was for me a significant self- discovery. I learned that I could make things without the benefit of training or

instruction. That was the beginning of my free, uninhibited, and humorous creations.

Some Principles of Creativity

After I started doing landscaping and sculpture in Cape Coral, I kept asking myself, "What things are worth doing and why?" In my attempt to answer this simple question, I learned that what I made and how I made them actually followed some principles. As I discovered in Brasstown, I made what I saw in the materials. I let the materials tell me what to do. I also allowed the natural characteristics of the material to tell me how to carve.

THE TAOIST POINT OF VIEW

I was born and raised in the Philippines. I have also studied various Chinese schools of philosophy. I did not realize that, culturally, I have been strongly affected by the Taoist philosophy. I did not consciously apply Taoist principles to my creativity; it just happened that my natural way of making things seem to conform to Taoist principles.

The Tao simply means way, road, a way of life, a point of view. Because life is a journey, that journey must take a road, a Tao. For this reason, the idea of Tao is universal in Chinese philosophies. As may be expected, there is no one way of explaining what Tao means. Confucius gave Tao a moralistic meaning. In Taoism, as a philosophical school, Tao has a metaphysical meaning. Tao is the basic force that enables yin, the female passive principle and the yang, the active male principle, to unite and cause things to evolve.

Lao Tzu (6th century B.C.) was the principal proponent of Taoism. He had this to say about the Tao:

> The thing that is called Tao is eluding and vague. Vague and
> eluding, there is in it form. Eluding and vague, in it are things.
> Deep and obscure,in it is the essence. The essence is very real;
> in it are evidences. [Chan, p. 150]

In what Lao Tzu called essences, which are real, are the concepts of yin and yang. It also contains the central force of balance or harmony. The

goal of organisms as well as the universe is to create and maintain harmony or balance. When balance is disturbed, then illness occurs.

Balance and harmony are more easily achieved by going along with what nature dictates. This primacy of nature runs counter to the Western way of looking at things. The Westerner imposes his will upon nature.

The Taoist man is meek and humble; he regards weakness as strength. He is plain, simple, unselfish, and has few desires. Chuang Tzu, one of the Taoist philosophers, best expresses this outlook. This is what he wrote about the life of a wise man:

> For the Wise Man, life is conformity to the motions of Heaven, death is but part of the common law of Change. At rest, he shares the secret powers of Yin; at work, he shares the rocking of the waves of the Yang. He neither invites prosperity nor courts disaster. Only when incited does he respond, only when pushed does he move, only as a last resort will he rise. He casts away all knowledge and artifice, follows the pattern of Heaven...His life is like the drifting of a boat, his death is like a lying down to rest. He has no anxieties, lays no plans. [Chan, p. 208]

The Taoist Artist. The Taoist artist normally does neither predetermine nor pre-plan an artwork. He waits and allows the Tao to move or inspire him on what to do and how to do it. He surrenders personal will to the will of the Tao, a trait which distinguishes him as a Taoist.

Being metaphysical, the Tao cannot be seen nor heard. However, it can be understood by the mind in the process of interaction between the Tao and the artist. The interaction is mediated by the materials being used, the sites of the installation of artwork or the purpose for which an art piece is made. Hence, the artist is passive, waiting for the Tao to manifest its will.

The artist understands the Tao when the natural characteristics of the materials are revealed. Every material has inherent properties that set the limits and potentials of what can or cannot be created from it. The artistic medium tells the artist what it wants to be.

Another approach to Taoist creativity is for the artist to ascertain what he or she sees in the material. The seeing "something" in the object gives

rise to the artistic idea which guides the creative process and becomes the essence of the artwork. It is the essence that provides continuity and permanence in the meaning of the art object. It is the essence that the viewer understands in the artwork.

What does the viewer understand as he or she gazes at Michelangelo's *David*? What was the sculptor's artistic idea when he chiseled away tons of marble that did not belong on the sculpture?

I can only reminisce my own thoughts when I saw *David* many years ago in Florence, Italy. I was awed by its magnitude, elegance, masculinity and beauty. The sculptor seemed to be saying, "Behold, the magnificence of a human being! His external grandeur reflects the inner beauty of his soul. He is a paradigm of human perfectibility that all humans should emulate!"

Those were essentially my thoughts then, and they have persisted today. I assume that others see something similar, but may articulate their thoughts differently.

(Note: It was necessary to underscore the meaning of a work of art. However, the Western reader may see it as a digression from Taoist art. To a certain extent, it was a digression because it was a Western example of the meaning of art. A Taoist art too has an essence but I did not want to use an Eastern artwork as an example for Western readers.)

There are significant differences in the approach to life and art between East and West. To a certain extent, the East romanticizes nature, humanism, passivity, fatalism and subservient will. The West glorifies modern technology, theism, activity, self-determinism and non-subservient will.

Hence, it is understandable why Taoist art is nurtured in passivity and inactivity. But the artist's subservient will is at the beck and call of the Tao. When artistic inspiration strikes, the passive-inactive artist comes to life. He or she becomes playful and exploratory. From inconsequential activities may come artistic creations.

The Taoist is playful and not serious about his activities because he or she does not know how things will turn out; he does not know because he or she is fatalistic. The artist does not have the control of the outcome and

leaves it to Tao. Indeed, as Chuang Tzu said, life is uncertain; it is like the drifting of a boat.

While writing this portion of the manuscript in Cape Coral, Florida, I decided to undertake a small art project using only Taoist principles and test anew their validity. I cut down the lowest branch of a large bush that was covering other plants below. My initial purpose was to cut the branch into shorter lengths to be hauled by trash pickers. As I was cutting the smaller branches, I saw the shape of a snake and became determined to clean it up, dry it in the sun and carve the features of a snake.

After I had carved the mouth, I decided to bring out other snake features such as its scales and colors. I further enhanced the colors with polymer clay. I worked spontaneously, without any clear idea as to what it may look like in the end.

When it was finished, it looked unique and beautiful and I completely enjoyed the artistic process. Therefore, I am convinced that the Taoist approach works. I especially liked its spontaneity and blind boldness. Because the artistic process is fluid and imprecise, the artist can hardly go wrong. In the ten years that I have been doing Taoist art, I have never made a work that I did not like or regretted making. And because I never know how they will come out, I am always surprised and pleased with the outcome.

One reason why a Taoist artist is always pleased is because the artist is not a perfectionist and has no preset expectations. Taoist creativity is the natural result of passivity. The Taoist artist does not try hard. He goes with the flow as his spirit moves him. Doing art in a Taoist way is actually easy and spontaneous. The artist goes along, following the natural structures and characteristics of the material.

The Western Point of View. Without doubt, some of the Taoist advise for living is too alien to me because I am both from the East and the West. It is true that I was born and raised in the Philippines. But the country had been a colony of the United States for 47 years before it became politically independent in 1946. Moreover, I have been a resident of the United States since 1965 and a US citizen since 1970. For this reason,

my point of view is a combination of both East and West. In some cases, I am partial to the Taoist approach. In other cases, I utilize the Western method.

The Artistic Idea. A more typical approach to western creativity starts with an artistic idea in the mind. Often an artist entertains a number of ideas, almost all at once. I know some artists who have notebooks full of drawings for possible projects. The artist chooses an idea that, for the moment, seems most compelling. In times of war, for example, the artist may want to portray world peace.

Visualization and The Imagination. How does the artist proceed from an artistic idea to the actual making of a work of art? The next step, after the artistic idea, is to see in the mind's eye how the artwork may look. This is called visualization. Every artist uses the imagination. Visualization is seeing what the eyes do not see.

Formally trained artists normally use drawings as aids to visualization. They call their drawings "studies." Hence, the artists who keep drawings of possible art projects are already in the second level of the creative process. Sculptors tend to use three-dimensional studies called "maquettes." They are miniatures of what they hope will become a finished marvel.

The imagination is also what we use to understand artwork. Take for instance a performance by Marcel Marceau, a mime. He walks across the stage apparently pulling something on one side of his body, while looking back. The viewer understands that he is mimicking a man walking his dog. The understanding occurs because the viewer is able to imagine the existence of other things that he or she does not see, namely, the dog and a leash.

In a similar manner, we understand a painting by imagining other forms that are not explicitly shown. But even the forms that are explicitly depicted are only symbolic representations of certain realities. Remember the pipe painted by a French artist, Rene Magritte? Below the pipe, the artist wrote, "This is not a pipe." Yes, of course, it is only a painting of a pipe.

The role of the imagination is vital to creativity. The artist must be able

A. Cape Coral Landscaping and Gardens

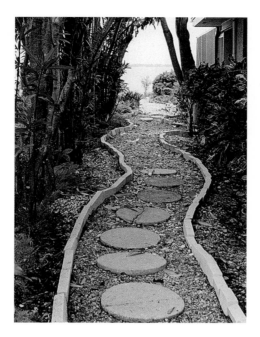

These pathways leading to a mile-wide river that flows into the Gulf of Mexico, symbolize limitless possibilities of life both by land and sea.

Photos by David S. Hamilton

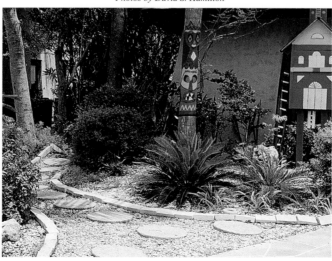

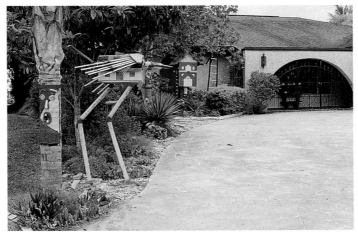

The driveway is also a pathway that leads to other pathways and waterways. The house represents shelter, rest, food, and comfort. The sculptures present points of interest along the driveway and the house.

Photos by David S. Hamilton

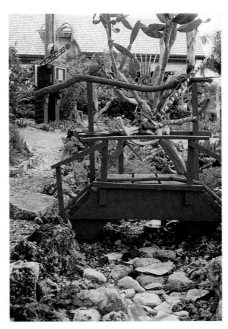

The ditch-like waterway represents the Caloosahatchee River that empties into a pond which represents Lake Ocheechobee. The bridge gives the idea of relations and communication.

B. Boone Landscaping and Gardens

 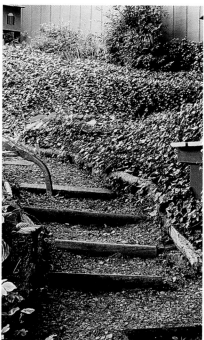

These pathways portray the human struggle in life.
We need to climb in order to achieve our goals.
The steps show the risks of falling or failing in our endeavors.

Photos by William A. Bake

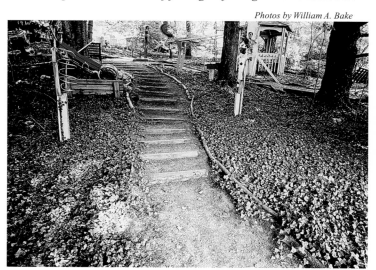

C. Boone and Cape Coral Whimsicals

Cape Coral Sculptures

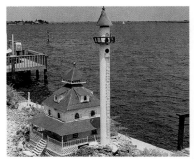

The lighthouse symbolizes direction and safety. The light keeper's house represents rest, warmth, and comfort.

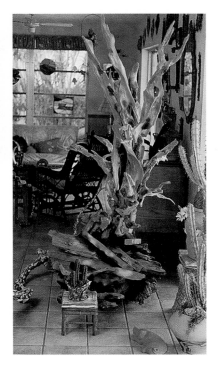

The flame symbolizes enlightenment and civilization. It is made of driftwood, horn, and scraps of wood.

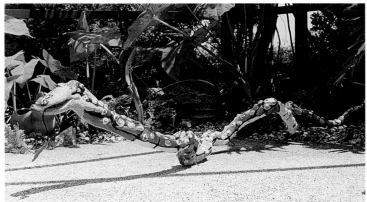

Photos by David S. Hamilton

This snake was made using Taoist principles. It is a tree branch, enhanced by polymer clay and acrylic paint.

Boone Sculptures

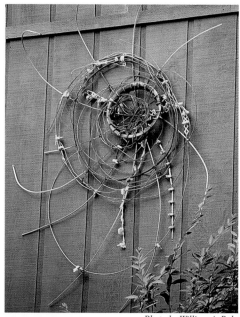

This wall hanging is a monument to hurricanes and all natural forces. It is made of wires, a hubcap, vines, found materials and acrylic paint.

Photo by William A. Bake

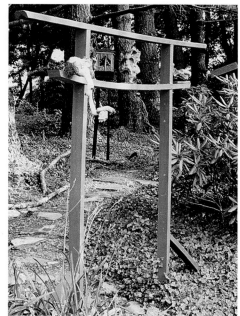

Photo by William A. Bake

The pagoda is the gate to the sculpture gardens.

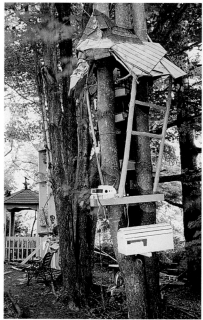

A tree house in the shape of a bird. It symbolizes isolation, freedom and a higher perspective.

Photos by William A. Bake

The belfry symbolizes communication and community.

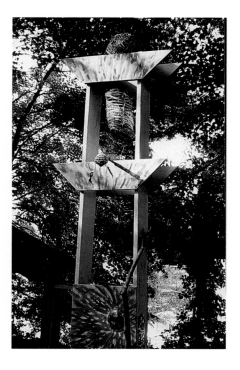

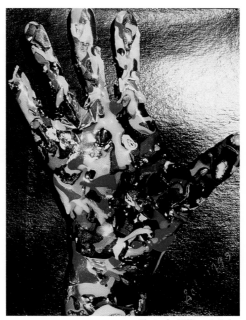

The right hand is a symbol of power and authority; it is made of fused stained glass in a clay mold.

Photos by William A. Bake

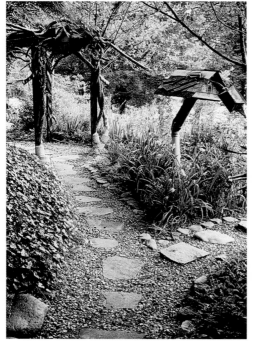

This house bird has a house for its head. The Unicorn is a mammalian arbor. Both oversee the pathways of life.

D. House Birds in Boone

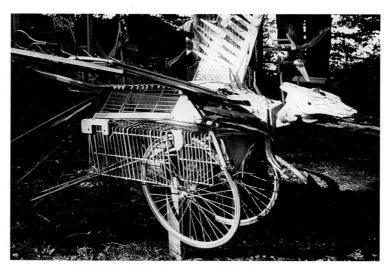

*The Road Roller is a shopping cart with a head of carved driftwood.
Its wings are fireplace screens, and a scrap of wood is its tail.*

<div align="right">Photos by William A. Bake</div>

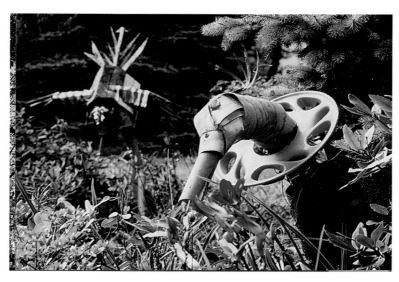

*This sculpture, a tribute to Stravinsky's Firebird Symphony,
is made of a tree root, roofing materials,
a hubcap, aluminum, and fused glass.*

House Birds in Cape Coral

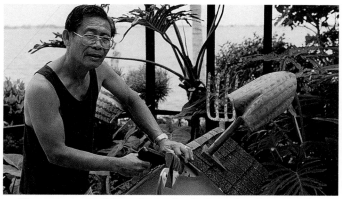

Photo by David S. Hamilton

The artist assembles a house bird whose head is a scythe, wings are shovels and tail is a pitchfork.

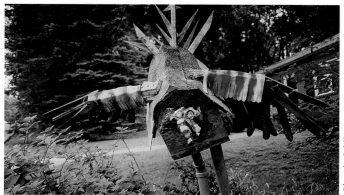

Photo by Sal Kapunan

This house bird appears ready for flight, with polyvinyl chloride legs, wood and metal wings, and a carved root for its head.

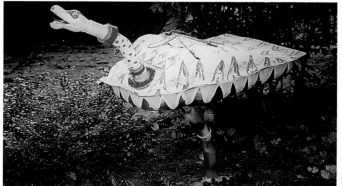

Photo by Sal Kapunan

This Ugly Duckling is an automobile gas tank with a head and neck of forged brass.

E. Human-like Sculptures in Cape Coral

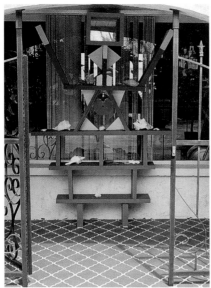

This welcoming sculpture, in the form of furniture, is made of wood and stands in the front atrium of the house.

Photos by David S. Hamilton

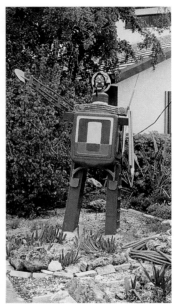

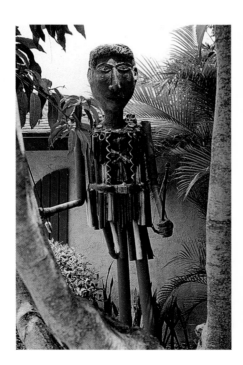

This greeter, made from a dishwasher, has arms made of crutches; his hands are made from shovels.

Caloosa, chief of an extinct Indian tribe, has a head of concrete. The rest of him was created from polyvinyl chloride that had been used for solar heating of our swimming pool.

Human-like Sculptures in Boone

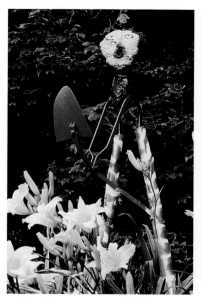

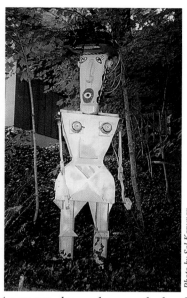

Photo by Sal Kapunan

The plowman is a tribute to the working people of Appalachia.

A vacuum cleaner became the head and hairdo of this proper looking lady. A phone receiver became her nose, and her mouth is fused glass. Her breasts are coffee cups.

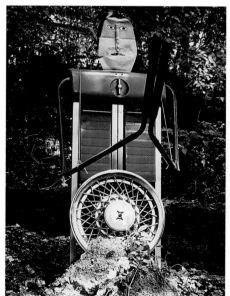

The Emerging Buddha was created from cross-country exercise equipment. His head is metal, with a bottle opener as his nose. His facial features were painted with acrylic.

Photos by William A. Bake

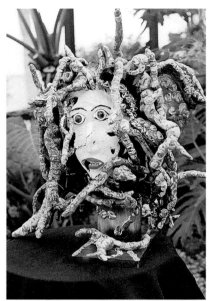

Medusa stands for female beauty and the potentially awesome power of women.

Photo by David S. Hamilton

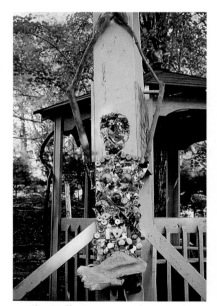

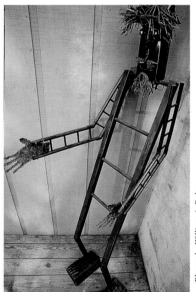

Photos by William A. Bake

The Ballerina, my tribute to the performing arts, is a mosaic of fused glass, mirrors, bottle caps, and broken glass. A giant platform mushroom forms the lower fringes of her tutu.

The Ladder Man's head is a mailbox, and his hands are fused wineglasses. He symbolizes human struggle.

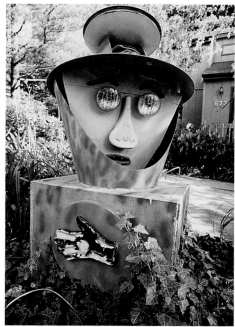

The Fire Goddess is a monument to civilizing fire, a symbol of enlightenment.

Photos by William A. Bake

The Teacher is a chair draped with women's clothes. Her head, made of styrofoam, is covered and formed by paper mache. Other features are painted with acrylic paint.

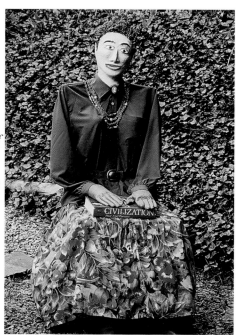

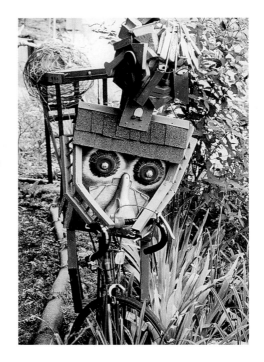

*This Biking Girl is a
tribute to all women
who struggle because
of their gender.*

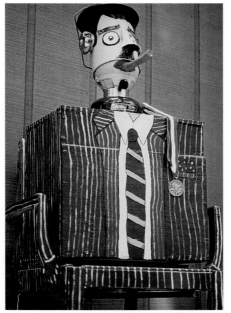

*The Chairman of the
Board is a monument to
all leaders.*

Photos by William A. Bake

F. Totem Poles in Cape Coral

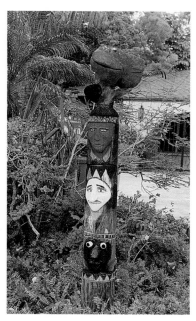

The totem pole makes a statement against powerboat speeders, whose propellers kill the endangered manatees living in our waters. The top figure is the severed head of a manatee. The faces represent the culprits, who are crowned by a real propeller.

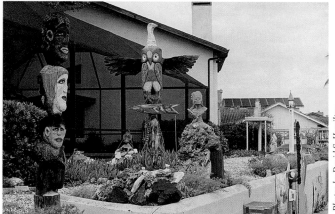

Photos by David S. Hamilton

The totem pole of four races is companion to the totem pole of predators and prey. The predators are alligators, eagles, owls and humans. The common prey is the fish.

G. Brasstown Carvings

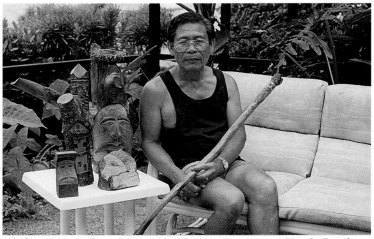

Photo by David S. Hamilton

The artist, with early carvings done in Brasstown, North Carolina. These carvings were the first indications that he could create things without the benefit of formal training.

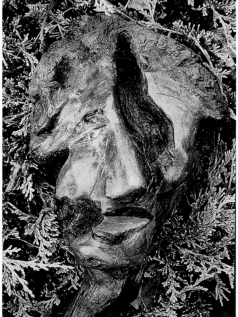

Photo by William A. Bake

The Man with a Hole in his Head is a self-portrait. The hole implies something unknown, mysterious, idiosyncratic, and possibly even insane.

to imagine not only what exists but also what can possibly exist. He must be able to imagine unheard-of things and manipulate them to create new forms. In a sense, artists create *ex nihilo* (from nothing) from their imagination.

Using Symbols for Visualization. Many artists use symbols to help them visualize an idea. The symbols, then, become part of the actual composition. There are different types of symbols. Some symbols are natural, such as smoke, lightning, and clouds. Many more symbols are artificial or cultural, such as flags, arrows, fireworks, and monuments. There are symbols that are purely personal. An artist may take a natural or artificial symbol and give it an added personal meaning. Or, the artist may create his own symbols and their meanings.

Let us return to the artistic idea mentioned earlier—world peace. A globe or the earth has often symbolized the world and a dove has symbolized the idea of peace. Part of the visualization process is to imagine how the symbol, dove, relates to the globe. How big should the dove be in relation to the globe? Should the dove hover over the globe or should it rest on it? If the dove hovers over, should the artist abstractly represent it simply by two wings? Should the artist show the whole globe or only a hint of it? These are some of the decisions the artist has to make in the process of visualization.

My Personal Symbols. As a "Taoist" artist, my primary symbols are not embodied in the sculptures, carvings and wall hangings. Instead, they are walkways and pathways that suggest the meaning of "Tao." In Boone, North Carolina, the pathways conceptually start at the *pagoda* in front of the house. The *pagoda* symbolizes the gate to the sculpture gardens.

The pathways converge and divide towards different directions. Every time the pathways bifurcate or subdivide, the walker must choose a path that, conceptually, may be right or wrong. Hence, the walker takes the risk of making a wrong decision.

The pathways vary in width, curvature and shapes to signify the many different courses that any walker may take. Every day, the walker must

take a new course. Even if the route has been the same every day for the past ten years, it is still a new route for the day that the walker chooses anew. For that day, all decisions, choices and actions would be new even if they had made the same choices, decisions and actions a million times before. Each route to be traveled represents something unknown, exciting and may pose some possible danger.

Our homes have been intentionally situated along our pathways. They present for us opportunities to rest, to eat and to seek shelter from rain, storms and other dangers.

Life in the home illustrates the centrality of walkways in our lives. To be alive is to move. Every time we move, we move to a destination: the bathroom, kitchen, living room, bedroom, library, computer room and so on. Every motion we take uses a walkway which may be clearly delineated or delineated only by the mind or the imagination. The less clearly delineated a walkway is, the greater the risk one takes in walking.

In virtually every home, walkways are only generally delineated: to the bathroom, bedroom, kitchen and so on. In fact, there are hundreds of imaginary walkways that overlap in various sections of the floor. Therein lies the potential danger of accidents. If someone inadvertently leaves something at the hub of the walkways, someone may trip and be hurt.

Clearly then, every step we take has inherent risks. Every step we take is a venture to the unknown. But tread we must because to live is to walk.

Along the pathways, too, are benches, a hexagonal gazebo, a hammock, a swing and some rocks that may provide rest to the walkers and some view of beautiful mountain scenery and the sculpture gardens.

The semicircular driveway is part of the pathways. It serves both as a pathway and a driveway. It looks like open arms that welcome visitors. It provides parking spaces for cars and other vehicles. It makes connections to a public street and other streets. For this reason, we can drive to a train station and board a train across the country. We can drive to an airport and take a plane across the world. We can drive to a seaport and board a ship that takes us across oceans. Such is the "Tao" of many modern, more affluent Americans.

Our pathways in Cape Coral, Florida, have additional dimensions. While

our semicircular driveway may be the starting point to explore the world, our backyard has a boat on an elevator at the bank of the Caloosahatchee River. The River is a naval shortcut from the Atlantic Ocean to the Gulf of Mexico and vice versa. It is Florida's version of the Panama Canal. Hence, our pathways become waterways. We can navigate eastward to the Atlantic Ocean and beyond; we can navigate westward, in twenty minutes, and be in the Gulf of Mexico. Through the Intracoastal Waterways or the oceans, we can visit various southern and eastern coastal cities. Through the Mississippi River and its tributaries, we can also navigate to many more cities all the way to the Great Lakes and into Canada. Indeed, knowing the "Tao" gives us many more possibilities of extending our pathways and waterways in life.

The symbolism of pathways provides unity to all the artwork along the walkways. This unity is not just physical but conceptual. The walkways symbolize our journey through life. While each artwork has its own symbolism, taken together, they symbolize points of interests that we experience in life. The walkways also provide a transcendental character to the symbolism since the meaning of pathways goes beyond the actual location of the artistic creations. As I pointed out in the preceding paragraphs, the pathways are connected to roads and transportation systems. Hence, the symbolism of pathways has global and universal application. This is because it is about the road we have chosen to live; it is about our "way of life.'

I have also used secondary symbols for different purposes. I have built steps on some walkways to remind the traveler of the risk and effort entailed in climbing up or down. I have often used ladders as legs and arms of sculptures to underscore the fact that life is a struggle and is fraught with risks. Every project or task we undertake entails literal and metaphorical ladders. Ladders remind us that we can fall or fail in our endeavors. In our mortal lives, nothing is guaranteed.

I have also used houses as symbols of success. Many of our efforts have been rewarded with home ownership and other creature comforts.

Among my favorite and recurring symbols is the extensive use of trash which underscores our wasteful and disposable industrial society. I have

imbued them with a new, artistic life. Implicitly, I am urging the viewers to recycle artistically or otherwise.

I have used many different materials for their symbolic value: roots symbolize stability and relative permanence; driftwood, while floating, symbolizes impermanence, instability and lack of direction (Driftwood is a good metaphor for a true Taoist); rivers and lakes for their suggestion of travel, adventure, recreation, food sources and natural beauty; bridges for relationships and interconnectedness; wheels for technology, travel and ease; bell tower for telling us the time of the day or night and other useful information; plow to remind us of our need to toil and gratitude for nature's bounty; flame for fire, heat and energy; sunburst to remind us of the life-giving sun that illuminates our days; hurricane to warn us of nature's fury.

I have used many other symbols such as different colors. I have made monuments to various personages, natural phenomena and mythical beings. Viewers have pointed out many more symbols in my work that I did not advert to nor intended. I am very grateful for their input.

Some of My Artwork

As I take inventory of what I have made during the past eight years, I realize that they might be divided into 6 categories. They are Decorative Pieces, Whimsical Pieces, Landscaping and Gardening, Architectural Design, Symbolic, and Monumental Works.

DECORATIVE PIECES
This category consists of wall hangings, mobiles, and small carvings. These pieces were made for specific walls, ceilings or spots in our homes in Cape Coral, Florida, and Boone, North Carolina. The materials used for wall hangings were vines, electric wires, rattan strips, cardboard packing, ribbons and tree barks. The mobiles were made from roots, drift woods, shells, golf balls, fused glass, hubcaps, and other "found" industrial materials. The small carvings were made from roots, driftwood, and scraps from construction sites.

WHIMSICAL PIECES

Many of my whimsical creations came from my Taoist perspective, explained earlier. I have also made sculptures from every castaway appliance I could find. They were a real challenge but I was trying to make a statement about the need for everyone to recycle. I have made sculptures out of dishwashers, vacuum cleaners, hair dryers, curlers, and many others.

Among my amusing creations were birdhouses that look like birds. After I made a birdhouse, I would carve a head and attach it to one end. Then I would make a tail, wings and legs. I would install them in such a way that they seem to be doing something. Because they look like birds, I call them "House Birds."

I also made birds and reptiles out of shopping carts. One big favorite among visitors in Boone is what I call the "Road Roller." It is made of an inverted shopping cart. It has a magnificent head carved out of driftwood. Its wings are made from fireplace screens, wood, and aluminum strips. Instead of legs, it rolls on bicycle wheels.

One day, I took my car for repair at B. Miller Ford in Boone. While waiting, I asked permission to clean up their dump. I picked up a gas tank, a carcass of a car door, and a car bumper. Out of these treasures, I turned the tank into a duck; the door carcass became a cow; and the bumper became a sailboat.

One afternoon, my wife and I decided to hike up to the mountain peak called Howard's Knob in Boone. We had no clear idea of the actual distance. After hiking for about three miles, we realized that there were another seven miles to cover.

We turned around but chose another route we were not familiar with. The scenery downhill was just spectacular. We passed by small farms. In one of the farms, I saw an old broken plow, which I knew I could use for my art. I knocked at the door of the farmhouse. A black farmer came out. I offered him five dollars for the plow, which he accepted.

Meanwhile, Ruthe saw two other old pieces: one was a plow with a bicycle wheel and a large chain welded together to support a mailbox. I offered him another five dollars for both the pieces.

"No," he responded, "I cannot take more than $8 for the three pieces.

They are just junk."

He offered to deliver them to my house the next day.

I turned the chain into a cobra snake, I transformed one plow into a praying mantis, and I recreated the other plow into a monumental sculpture, which I will discuss later on.

LANDSCAPING AND GARDENING

After my artistic self-discovery in 1988, my first serious artistic endeavor occurred in October that same year. We discovered, while we were away for summer, that mole crickets feasted on the roots of our Bahia grass lawn. I decided to redesign the landscaping and get rid of the lawn altogether.

Since our house is on the banks of the Caloosahatchee River, I was going to build a facsimile of it on our front yard. The headwaters of the river start from Lake Ocheechobee, in the south central part of the state. The river empties into the Gulf of Mexico. I took artistic license and changed the natural order. I would make the river empty into the lake so I could build a pond that would represent the lake.

As I dug my river and lake, I actually dug out tons of coral rocks, with thousands of marine fossils visible. I found out that the river, which is over a mile wide, is really an estuary of the Gulf. At one time, the water was more saline than it is now and there were coral reefs around the estuary. When they dredged the river in the 1960s to build boat channels, they deposited the rocks and silts on land to elevate the marshland.

I decided to use the rocks as natural retaining walls for both the ditch and the pond I was digging. Then, I designed and constructed walkways. The walkways created "islands" which I transformed into rock gardens. To make each garden maintenance-free, I planted cacti, succulents, and ground covers. To add further interest, I made site-specific sculptures in each garden.

Southwest Florida is flat. To change the view, I decided to build a small pile of rocks, which I also used to support our mailbox. I call this mound of rocks "The Rocky Mountain."

BOONE LANDSCAPING AND GARDENS

When we decided to build our summer home in Boone in 1990, I used the same technique of landscaping I had used in Cape Coral. First, I designed

the pathways as the contours of the land naturally suggested. Boone is in the high country of Appalachia. Our homesite is heavily wooded with trees over 100 years old; yet, it is only a block away from King Street, the center of the city. For this reason, our homesite is virtually level and we use every inch of the land.

I designed the pathways in such a way that they converge at certain junctions, separate into different directions, and converge again at some other point. This process created several "islands" which became separate gardens.

Because of the abundance of trees in the mountains, tree roots became my primary source of art material. I used roots for forming heads of humans, birds and many animals. Of course, I continued to use "found" materials at least as components of my compositions. As I dug my pathways, I unearthed roots, stumps, and all sorts of industrial castaways. My barber, Jerry Wilson, who is 90 years old, told me that our homesite was a vacant lot when he was still a child. The land had been accumulating trash for a century or more. I found a car transmission, bumpers and all kinds of thrown-away materials. Everything became a sculpture or part of a sculpture to decorate our premises today.

The gardens too have become fully planted over the past seven summers. Our gardens are partial to hybrid day lilies which are spectacular in midsummer. Our yard and gardens won an award from the City of Boone in November 1990. The award, presented by the Community Appearance Commission, said in part, "This award is for Dr. and Mrs. Kapunan for their outstanding achievement in improving the aesthetic appearance of the Town of Boone, with the design and implementation of the architecture and landscaping at their home."

I wish I could say that the City of Boone awarded us for the architectural design of our house. In truth, the award was for the landscaping.

ARCHITECTURAL DESIGN

Our involvement in Philadelphia and also in Cape Coral in real estate renovation and construction have taught us about architecture and design. Since 1986, we have built over 15 rental houses in Cape Coral. This

background gave us enough confidence to design our house in Boone.

After designing the house, I built a scale model to give us a three-dimensional view of what it would look like. We made detailed specifications of measurements, materials to be used, paint colors, and other relevant details. We talked to three builders about our plans and asked each one to make a bid. We chose the best of the three. Ron Boyce built us a house that exceeded our expectations.

The house was designed to blend with the environment and the historic neighborhood. But the house was also designed as a sculpture. With some stretch of the imagination, one can see that the house has a human face. Two porthole windows are the eyes. A narrow roof over the entryway is its nose, and the front door is its mouth. Wooden decks from the front door and from the side balcony swing out in semicircles to symbolize welcoming arms. The semicircular driveway also symbolizes open arms.

Symbolic Artworks

I explained earlier the primary symbols I have used: ladders, houses, and castaway materials. The artworks that came out of these symbols were what I call "humanoids." They resemble human forms but their bodies look like houses, with windows and doors. In some cases, their heads also look like houses but they have human faces with eyes, noses, and mouths. They appear to walk with thighs and legs that look like ladders. Their arms and hands, too, are made of ladders.

The reason why I give them human features is because I am making a comment about the human condition. Like ladders, our hands, arms, legs and feet are our instruments to achieve a lot of things in life. If we work hard, we will have some tangible success like owning a house. Life is worth living!

Besides the primary symbols, I have used many others as well. I have used roots often because of their symbolism for stability and its connection to the soil. To me, roots symbolize nature itself. The "river" and "lake" I dug in Cape Coral symbolize food sources, recreation, fun, and travel. I built a bridge across the river, not just for decorative effect but because it symbolizes connections, convenience, safety, and travel. The pathways

remind us that life is a journey, that we have to choose our paths wisely. They also symbolize direction and the risk of getting lost. A pagoda in Boone symbolizes a gate to something holy or something important. In this case, it is a gate to a sculpture garden. A belfry, also in Boone, symbolizes communication because, historically, messages were sent miles around by the tolling of the bell or bells. The bell tolls differently when the community is summoned for worship, when someone dies, when someone is going to be buried. Even today, in many countries, towns, and cities, bells tell the community the time of the day and night. Hence, bells not only symbolize community; they actually create communities and communal unity.

A tree house, also in Boone, stands for independence, freedom, fun, and a higher perspective. In fact, Ted Kaczynski, the Unabomber, inspired the tree house. Sickened by modern technology, he withdrew from society and built a small cabin in the woods. If I were to withdraw from society, for whatever reason, I would build a tree house and fill it with all the technology I could afford. That is why my tree house has a television, a phone, a recording machine, a toaster, a can opener and a large mailbox.

In Cape Coral, I made a sculpture called "flame." It is made out of driftwood and painted with iridescent orange, yellow, and black. Fire is a symbol of knowledge, enlightenment, and civilization.

I have made a number of sculptures in which arms are opened wide in welcoming embrace. There is the Tin Man made from a 10-gallon paint can. His face is a lid and his nose and mouth come from the hardware of a mop. His limbs are made of wood scraps . He has just stopped working and is resting on his rake. He waves with his left hand and yells, "Hey!" Some parents have told me that they pass by our house often because their children want to say hello to the Tin Man.

Mammy Yokum, made from a cherry tree, also waves and hollers to those passing by, asking them to stop and visit. Gertie is another greeter and I will discuss her at length later.

Monumental Sculptures
A sculpture may be monumental, not by size, but by intent. Because historical monuments are often erected at government expense, they tend

to be gigantic in size. My monuments are very modest in size.

Chief Caloosa. The first monument I made was for an Indian Chief of an extinct tribe that inhabited southwest Florida, where Cape Coral is located. According to legend, the Chief converted to Christianity by Spanish missionaries and given the name Carlos (Charles). Carlos somehow became Caloosa and the members of his tribe became known as Caloosas. The tribe died out because of diseases brought by the Europeans to this region.

The sculpture was made principally from PVC pipes that once served as plumbing for a solar heating system of our swimming pool. When I had the system disconnected, I took down the plumbing and used them for sculpture. The head is made of concrete. His limbs are also made of PVC pipes. He carries a bow and arrow. The work is about 12 feet tall.

The Four Races. After a storm, a 10-foot dock piling washed against our boat dock. I decided to make two totem poles out of it. I carved four faces representing the conventionally accepted four races. The top face was black followed by white, then yellow and brown. The arrangement was purely arbitrary. I do not believe that one race is better than another.

Medusa. In Greek mythology, Medusa was one of the three evil Gorgons. She had deadly snakes for her hair. Her eyes were so piercing that they could melt people into stones. Perseus became a hero because he severed Medusa's head.

Her bust is made of a tree root. I made Medusa more evil by giving her some snakes that are loose and can be sent to kill her enemies at her behest. My Medusa has holes on her face where some of her snakes hide.

Medusa is my monument to the power of women. The myth reminds us that while women may appear weak and naturally passive, they are also capable of fighting and defending themselves. They are capable of inflicting harm on those who try to harm them.

Uphill Mountain Biker. During the summer of 1994, one of our neighbors in Boone gave me three perfectly good bikes. They were, however, useless for mountain biking. I turned all of them into sculptures.

I exploited the fact that these bicycles were not for mountain climbing to call attention to the natural hardships that women are subjected to

precisely because they are women. Using my ladders and house symbols, I made a young woman ride uphill using a bicycle made for level terrain. Nature demands that women bear and raise children, and in today's society, do housework and hold and maintain a job or a career. Hence, this is my monument to women who continue to nurture and foster social bonds in spite of the many injustices against their gender.

Her body is a house. Her limbs are ladders. Her hair is made of scraps of wood. She looks like a woman with a very bad hair day. She is biking at the edge of a precipice, and the handle is turning towards the precipice. She is clearly in a present danger.

The Fire Goddess. In the early summer of 1996, art professor, Sherry Edwards of Appalachian State University, gave me a rusty old freestanding fireplace. I cleaned it, scraped the rust, killed the rust with chemicals, and primed it with Rustoleum®. It was ready to be artistically recycled, but I did not know what to make of it.

When I turned it upside down, I saw the face of a beautiful woman. Her face is wood, her eyes are burnt spotlights, her nose is a bicycle seat, and her lips are lead strips for balancing tires. Her hairdo is a hubcap and a roll of electric wire. She looks like she is wearing a wide-brimmed hat. She is the goddess of fire. I painted the sculpture as if she is on fire, but she does not burn.

The Goddess of fire is the Goddess of enlightenment and civilization. In the myth of Prometheus, human civilization started when Prometheus stole fire from Mount Olympus and gave it to humans.

The Plowman of Appalachia. When I was buying an old plow from a black farmer, I asked him why the plow had a bicycle wheel attached to it. He explained that this particular plow was manually used by people, that the plowman pushed and pulled to operate it. That information was mind-boggling to me. I imagined how difficult it must have been to operate that plow.

I decided to make a plow sculpture as a tribute to the hardy, independent, and resourceful people of the Appalachian Mountains. I marveled at how they eked out a livelihood out of the virtually barren soil for generations.

I removed the wheel and replaced it with a human-looking head. In doing so, I inverted the plow. The face seems to evoke the emotions of pain and suffering. He seems to be yelling, "Woe is me!" Nevertheless, he is determined to push his plow.

Sunburst. At the back of the barn in Boone is a wall hanging which is about eight feet in diameter. At the center is a hubcap with a human face. Emanating from the center, and going into all directions, are sun rays in radiant orange, yellow, red, and all other colors. It is my interpretation of a life-giving and sustaining sun.

The wall hanging is a collage of vines, electric wires, fused glass, found materials and paint.

Hands. I made a clay form of my right hand; I then bisque-fired it in a kiln. I filled the form with assorted colors of scraps of stained glass. I placed the form in a glass kiln and heated it to 1500 degrees so the glass would fuse. The hand came out with spectacular color and grace. So, I made another hand but used different colors of stained glasses. The outcome was just as spectacular as the first. I framed each one separately and hanged them on our corridor wall in Boone.

The hands are my monuments to human dexterity and artistry. The right hand is a symbol of authority. We say about the person in charge that he or she handles matters and is our "right hand."

In the movie, "The Fall of the Roman Empire," the producers built a two-story building in the shape of the right hand. Out of the palm of the hand, the big door would swing out and Emperor Nero would then slowly walk out of the door in all his splendor, authority, and pomposity. It is an awesome scene because of the grandiose show of power and authority.

Hurricane Hugo. When the monstrous hurricane made landfall in Charleston, South Carolina in 1989, it did not turn northward as predicted. Because of its strong velocity, it continued inland and moved on westward through Charlotte, North Carolina, right into the walls of the mountains. It finally turned northward but only after causing tremendous damage in the mountains, including Boone.

Growing up in the Philippines, I have experienced a number of

hurricanes—we call them typhoons—but Hugo was the worst I have experienced. It was a nightmarish few hours of the house being hit by broken branches that seemed like missiles. The wind gusts were in excess of 100 miles per hour.

To make sure I would never forget that hurricane, I made a weaving of rattan strips, vines, and wire as my interpretation of hurricane behavior and force. It is a monument not just to Hugo but to all hurricanes and natural disasters. I wanted the artwork to remind myself always to respect natural phenomena and to get away from them as soon as possible.

Chairman of the Board. The primary component of this piece is a broken chair I picked up from the trash. I constructed a box on the chair to represent a male body. In a whimsical way, I made the chair's legs as his legs, and the chair's arms as his arms. For his head, I used an oil can mounted on the base of a kerosene lantern, which serves as his neck. The lantern light diffuser serves as his hat. His eyes are made from washers; an oil pourer serves as his nose. His mouth is painted in. Out of his mouth is the pourer that came with the oilcan. He looks like he is smoking a large, long cigar. He wears a blue striped suit, and a striped red and yellow necktie. He looks as square as any chairman of any board.

He is a monument to all leaders—government, civic, religious, business and industrial leaders. Leaders have to make difficult decisions for the benefit of their constituents.

Incidentally, this work won first place and best of show in an art competition held in Boone. It also won second place in an art competition held in Raleigh, North Carolina.

The Emerging Buddha. The emerging Buddha is a monument to our inner spiritual lives and to religions in general. Made of a cross-country ski, he looks like he has just come out of the bowels of the earth. He is dragging a good deal of dirt which may mean he needs more good karma and greater enlightenment in order to escape the cycle of rebirth. His hands are reverently held together in homage to life and the Great Absolute.

Self-Portrait. I discovered in 1988 that I could make anything I decided to do. But were my creations artistic? I did not think so. In fact, I refused

to call myself an artist.

While working on one of my sculptures in Boone in 1991, an elderly gentleman dropped by and asked me a strange question, "Are you ready to have your self-portrait hang in a museum?" I was dumbfounded and said nothing. I was absolutely convinced that a deluded man was talking to me.

He proceeded to explain his proposal. In exchange for a self-portrait, he would give me an original drawing done by a famous French artist. However, this drawing was done before the artist became famous. He asked me to think about it, and that he would call me the following week.

After he left, I went to talk to my wife and share the funny story. We both had a good laugh. However, there was a nagging doubt that I could not ignore. The gentleman was very articulate and he did not talk like a madman. In fact, he seemed like a nice and sane man.

I kept thinking about his proposal, as he requested me to do, and something clicked. I remembered reading in the local paper, a few weeks before, about a gentleman who collected self-portraits of area artists. I searched for the article and found it. The author, Jim Thompson, mentioned that Dr. Artine Artinian was a renowned scholar of French literature and an art collector par excellence. He mentioned that Artinian also collected self-portraits in the Palm Beach area in Florida and that Artinian had several valuable collections, including rare books, first edition books signed by their authors, original manuscripts by Guy de Maupassant, and personal letters sent to him by famous people such as Thomas Edison, Franklin D. Roosevelt, and Edward Bok.

I had no idea that I was dealing with an eminent art collector. Just the same, my problem remained. I simply did not think I was qualified. However, my wife tried to convince me to comply. She pointed out that what I thought about my work was immaterial. What mattered was that an art collector of long standing wanted my artwork for a museum.

Halfheartedly, I started to think about an appropriate medium. I went through my pile of tree roots. To my surprise, I found a root with a hole that went right through it. If I carved a face where the hole was situated, I would be able to carve a bust of a man (myself) with a hole in his head.

What I was trying to portray was my artistic self. I liked the idea of a hole. It symbolized something unknown, mysterious, idiosyncratic, and even crazy. After all, a hole is a defect. That is, indeed, my artistic self— a hole in the head.

When Artinian called the next week, he was very surprised to know that I had already finished it. I learned later how unusual my quick response was. Some artists had been solicited 5, 10, 15 even 20 years ago and have not responded to this day.

Nevertheless, Artinian has already collected over 250 self-portraits and continues to add to the collection every summer. He has donated his entire collection to the Appalachian Cultural Museum at Appalachian State University.

Since 1991, the *Man with A Hole in His Head* has been hanging in the museum. I am grateful to Dr. Artinian for seeing the artist in me before I saw it myself. I have finally realized why I was denying that I was an artist. What I was really denying was that I am an artist in the academic, mainstream sense. I am really a Taoist Visionary Artist.

Gertie, The Greeter

Gertie has become famous not only to those who see her at the entrance of the Appalachian Cultural Museum in Boone, North Carolina, but also to those who access the museum in the Internet. She introduces the museum online. The Web site is *http://www.acs.appstate.edu/dept/museum*. According to Dr. Charles (Chuck) Watkins, the museum director, queries have come from all over the world.

In August 1992, Watkins commissioned me to create an appropriate sculpture for the entrance of the museum. He had no specific guidelines, so it was left to me to determine the project.

THE ARTISTIC IDEA

I thought of a female greeter since I knew that women were naturally more friendly, affable, and hospitable than men. I would use my basic symbols of house and ladders. She would have open arms to welcome visitors. She would have feminine curves and coiffure. Her facial features

would be delicate and feminine but not necessarily beautiful.

VISUALIZATION OF THE ARTWORK

The next step was to visualize the idea. In order to determine the size, I had to visit the specific site of installation. Since the site was quite open and there were tall trees in the background, the sculpture would have to be at least six feet tall. To this height, I had to add the length of the material to be buried in the ground. Based on six feet height, I had to determine proportionately the length of the limbs.

I could imagine a female figure whose body would look like a house, with ladders for her thighs, legs, forearms, arms, and hands. I imagined how to create the curves on the house. I imagined a tree trunk for her neck and a rhododendron root for her head. She would be facing east and her gaze would be cast at the sidewalk facing pedestrians. Her arms would be extended so many feet so that they would be immediately seen. I had a very good image of Gertie before the actual work was started.

THE MAKING OF GERTIE

Gertie was made and assembled over a period of two weeks. Some interesting things happened in the making of Gertie. For convenience, I had worked on the project around my house. I worked on a spot where I intended to install the male counterpart of Gertie. This device would give me some idea of the dimension of the sculpture I would call *The Moonshiner*.

As I worked on different sections of the sculpture, there was a gradual transformation of the environment. Since the site where I was working was visible to motor and pedestrian traffic, I noticed some degree of interest in what I was doing.

There was also a psychic transformation on my part. This may be due to the interplay between the conscious and unconscious minds. As I interacted with my medium (mostly wood) and as the different parts were taking shape, my perception was also evolving and changing as dictated by the progress of the work.

Without being completely conscious of the process, I had to assume that I was summoning into consciousness some aesthetic principles as

needed. I also had to continually recall my visualizations of every part of the sculpture. I had to apply engineering skills to put this sculpture together so that it would stay intact for at least 20 years.

As Gertie was nearing completion, my excitement was intensifying. My curiosity as to how it would look was overwhelming and I assembled the whole sculpture where *The Moonshiner* will later stand. I was happy with what I saw and I was ready to install it where it truly belonged.

INSTALLATION AND CELEBRATION

On September 7, 1992, Chuck Watkins and I dug a hole, poured concrete, and braced the sculpture until the concrete dried. Meanwhile, formal inauguration was scheduled. Invitations were sent and a press release was issued. The press release read, in part:

> Kapunan sees his sculpture as extending from Taoism, an oriental philosophy, based upon the idea of following what nature dictates rather than the western concept of imposing one's will on nature. Kapunan says he not only works to please himself but also notes that "It is a singular pleasure when children are responsive." Thus, thousands of people who annually come to the museum, many of them children, will find someone new and special awaiting them when they arrive—Gertie, the Greeter by Kapunan.
>
> His garden has become a Mecca for tourists and art lovers alike. To them, it's a wonderland, but to Kapunan, philosopher and artist, the garden is simply a natural merging of ultimate principles that govern life and the universe.

How My Artwork Has Affected My Life

My artwork has made our homes not only unique but also interesting. They have enriched our neighborhoods and the cities we live in. Because of several articles written and television interviews that were aired by several network stations, tourism has increased especially in Boone. It is not unusual for tourists from many states to ring our doorbell to meet the artist they saw on television.

Because our house is on a street corner in downtown Boone, and

because the sculptures are large and conspicuous, the property has become a tourist mecca. It is safe to say that most people in the Boone area know about the sculpture garden.

Definitely, my artwork has changed my life in interesting ways. It has opened new acquaintances and even friendships with a number of artists and interesting people. It has opened a new area of my life that I did not know existed. I have embarked on a new journey that has been exciting and rewarding. Having done the many sculptures that now decorate our homes, I feel more confident about myself. I have a greater sense of fulfillment and a higher sense of self-integration. These factors have given me the motivation to share my knowledge and insights with others by writing this manuscript.

As it turns out, my artwork is serving as my entryway to a different career—being a writer. I have not abandoned art because writing is a form of art. What I have done is to change the artistic medium. Instead of assembling materials like shopping carts, driftwood, tree roots and found materials, I am now assembling words and ideas. I have found the new medium just as exciting and interesting as other media. It is also easier to do.

So, I am just beginning to be a writer. I undertook making art without formal training. I am also embarking on my writing career without formal training in writing. This manuscript is the trial balloon, the magic carpet, to an exciting new career. Wish me luck!

My next writing project is entitled *Everyone is an Artist*: *Our Three Artistic Faces*. The picture I am painting, with words, is the life that each person lives. Every person is an artist whose artistic medium is himself or herself. Every day, the artist works on his or her face, body, personality, reputation, health, life, psyche, and livelihood. The artwork, in progress, is the "Self." Hence, in the art of life, the artist, the medium, and the artwork is one and the same—"The Self."

Art is not some frivolous work that artists do. It is the very thing that makes life worth living!

Selected Bibliography

Cardinal, Roger. *Outsider Art*. New York, NY: Praeger, 1972.

Chan, Wing-tsit, comp. & trans. *A Source Book in Chinese Philosophy*. Princeton, NJ: Princeton University Press, 1963.

Debufet, Jean. *L'Art Brut Prefere Aux Art Culturels*. Paris: Galerie Rene Drouin, 1949, p. 41.

Hall, Michael D. and Eugene W. Metcalf Jr., eds. *The Artist Outsider: Creativity and the Boundaries of Culture*. Washington, D. C.: Smithsonian Institution Press, 1994.

Hartigan, Linda R. *Made with Passion*. Washington, D. C.: Smithsonian Institution Press, 1991.

Hemphill, Herbert and Julia Weissman. *Twentieth Century Folk Art and Artists*. New York, NY: E. P. Dutton, 1974.

Janis, Sidney. *They Taught Themselves: American Primitive Painters of the 20th Century*. New York, NY: Dial Press, 1942.

Manley, Roger. *Signs and Wonders: Outsider Art Inside North Carolina*. Raleigh, NC: North Carolina Museum of Art, 1989.

MacGregor, John M. *The Discovery of the Art of the Insane*. Princeton, NJ: Princeton University Press, 1989.

Maizels, John. *Raw Creation: Outsider Art and Beyond*. London: Phaidon Press, 1996.

Maresca, Frank and Roger Ricco. *American Self-Taught: Paintings and Drawings by Outsider Artists*. New York, NY: Knopf, 1993.

Prinzhorn, Hans. *Artistry of the Mentally Ill: A Contribution to the Psychology of Configuration*, trans. Eric von Brockdorff. (Translated from 2nd German edition). New York, NY: Springer-Verlag, 1972.

Tuchman, Maurice and Carol S. Eliel, eds. *Parallel Visions: Modern Artists and Outsider Art*. Princeton, NJ: Princeton University Press, 1993.

Waley, Arthur. *Three Ways of Thought in Ancient China*. London: Allen & Unwin, 1939. (Reprinted by: New York, NY: Doubleday, 1956)

Index

A

Abby Aldrich Rockefeller Folk Art
 Center 6
American Visionary Art Museum 4
Appalachian Cultural Museum,
 Boone, NC 37
Art brut 3, 5, 6
Artinian, Dr. Artine 36
Artistic idea 22

B

B. Miller Ford, Boone, NC 27
Balance (Taoist philosophy) 18
Bok, Edward 36
Boone, NC 16, 26, 28, 39
Boyce, Ron 30
Broun, Elizabeth 7
Buddha (sculpture) 35
Buena Vista, GA 8

C

Caloosa (Indian tribe) 32
Caloosahatchee River 28
Cape Coral, FL 15, 26, 28, 31, 32
Cardinal, Roger 3
Castaway materials
 bicycle wheel 27
 gas tank 27
 plow 27
Chairman of the Board (sculpture)
 35
Chief Caloosa (sculpture) 32
Chuang Tzu (Taoist philosopher) 19
Community Appearance Commis-
 sion, Boone, NC 29
Confucius (Chinese philosopher) 18
Creativity, Artistic 22

D

Decorative pieces 26
Dubuffet, Jean 5

E

Edison, Thomas 36
Edwards, Sherry 33
Eliel, Carol 9

F

Fire Goddess (sculpture) 33
Flame (sculpture) 31
Folk art 3, 5, 6, 7
Found materials. *See* Castaway
 materials
Four Races, The (sculpture) 32

G

Gertie, The Greeter (sculpture)
 installation 39
 making of 37, 38

H

Hampton, James 7
Hands (sculpture) 34
Harmony (Taoist philosophy) 18
Hemphill, Herbert 7
Howard's Knob, Boone, NC 27
Hurricane (sculpture) 35

I

Imagination, Artistic 22

J

Janis, Sidney 6
John C. Campbell School of Folk
 Arts, Brasstown 16

K

Kapunan, Ruthe 16
Kapunan, Sal
 architecture and design 29
 art 13
 artistic symbols 30
 biography 14
 decorative pieces 26
 education 14
 landscaping and gardening 28
 monumental sculptures 32
 real estate venture 15
 self-portrait 17
 Taoist art 17
 teaching 14
 whimsical creations 27
 wood carving class at Brasstown,
 NC 16
King Street, Boone, NC 29

L

La Salle College, Philadelphia 14
Lake Ochechobee 28
Landscaping and gardening 28
Lao Tzu (Chinese philosopher) 18

M

Magritte, Rene 22
Mammy Yokum (sculpture) 31
Man with A Hole in His Head (self-
 portrait) 37
maquettes 22
Marceau, Marcel 22
Maresca, Frank 10
Martin, Eddie Owens 8
Masters of Popular Painting (Art
 Exhibition) 6
Maupassant, Guy de 36
Medusa (sculpture) 32
mentally ill, Art of 4, 5
Mikulski, Barbara, Sen. 4
Monumental sculptures 31
Moonshiner (sculpture) 38, 39
Mountain Times 36

Museum of Modern Art, New York
 City 6

N

Naive art 3
Naives and Visionaries 8
National Museum of American Art,
 Washington, D.C. 7, 8

O

Outsider art 3, 5

P

Palm Beach, FL 36
Parallel Visions *9*
Pasaquanites (imaginary tribe) 8
Plowman of Appalachia (sculpture)
 33
Polymer clay 21
Primitive art 3
Prinzhorn, Hans 5
Prometheus 33

R

Rockefeller Collection 5, 6
Roosevelt, Pres. Franklin D. 36

S

Santo Tomas University, Manila,
 Philippines 14
Self-portrait 17
Self-taught artists 3, 5, 6
Snake, carving of 21
ST. EOM. *See* Martin, Eddie Owens
Studies (artistic drawings) 22
Sunburst (sculpture) 34
Symbols, Artistic 23
 driftwood 26
 houses 25
 humanoids 30
 semicircular driveways 30
 steps 25
 trash 25

walkways and pathways
23, 24, 25
waterways 25, 26
world peace 23

T

Taoist art 17
Taoist philosophy 18
Temple University, Philadelphia, PA
14
They Taught Themselves 6

Thompson, Jim 36
Throne of the Third Heaven of the
Nation's Millenn 7
Tin Man (sculpture) 31
Tolson, Edgar 7
Tree house (sculpture) 31
Tuchman, Maurice 9
Twentieth Century Folk Art and
Artists 7

U

Untaught artists 3
Uphill mountain biker (sculpture) 32

V

Vernacular art 3
Visionary art 3
Visualization, Artistic 22

W

Walker Art Center, Minneapolis, MN
8
Watkins, Dr. Charles 37, 39
Weissman, Julia 7
West Chester State College, PA 14
Whimsical creations 27
Wilson, Jerry 29
Wood spirits (carving) 16

Y

Yin and Yang 18